MW00812094

TERMINATOR 2

TERMINATOR 2
JUDGMENT DAY

Screenplay by James Cameron & William Wisher
Adapted by Jeff Campbell
Illustrated by Work in Progress Studios

CHRONICLE BOOKS
SAN FRANCISCO

Printed in Hong Kong

A First Street Films Book

Typesetting by Margery Cantor

Work in Progress Studios: Jeff Johnson, Steve Jones, Scott Kolins, Brandon McKinney, Christopher Schenck

Library of Congress Cataloging-in-Publication Data available.
ISBN: 0-8118-2208-7

Distributed in Canada by Raincoast Books
8680 Cambie Street
Vancouver, BC V6P 6M9

10 9 8 7 6 5 4 3 2 1

Chronicle Books
85 Second Street
San Francisco, CA 94105

www.chroniclebooks.com

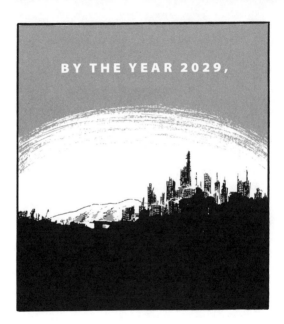

the earth was a scorched ruin. In what had been Los Angeles, blackened, crumpled cars sat in orderly rows of bumper-to-bumper traffic—exactly as they had been when in a single afternoon nuclear war nearly obliterated the human race.

That was August 29, 1997, and the survivors called it Judgment Day. But

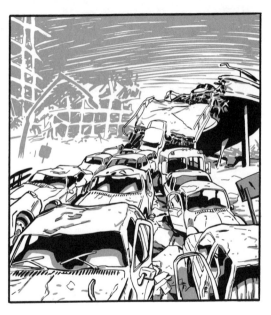

The survivors called it Judgment Day.

those who were left discovered they had a new enemy—the Machines.

In the years that followed, a juggernaut of mechanical warships hunted down the survivors; cyborg entities known as "terminators" infiltrated their underground bunkers. It was a hopeless battle, except for one man who rallied and organized the human Resistance: John Connor.

One man rallied and organized the human Resistance:
John Connor.

He targeted Skynet, the computer that produced and controlled the machines. And after thirty years of fighting, he'd turned the tide and was on the verge of destroying it.

To stop him, Skynet sent two terminators back through time. The first was sent to 1984 and programmed to kill John's mother, Sarah, before John was even born. It failed.

The second was sent to kill John as a child. As before, the Resistance snuck a lone warrior through to protect him.

It was just a question of which one would reach him first . . .

In a truck stop in Los Angeles, blue streaks of electricity arced between two parked trucks. A crackling sphere of energy appeared, shearing off the corner of a trailer.

The glowing orb dissipated, revealing a crouched, naked man. He stood and scanned the area, his face impassive. He was tall, muscular, physically perfect.

He was a terminator.

The terminator spotted a building. As he approached, he scanned the vehicles parked outside—a collection of motorcycles and a Plymouth sedan

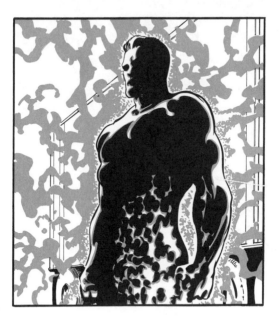

He was a terminator.

—and settled on a Harley-Davidson: "Criteria Match: .97."

Now, he needed clothes.

He entered the establishment, a rough country-and-western bar called The Corral, and electronically assessed each patron for type and size match, oblivious to their stares.

Naked men didn't wander in every night, and none like him.

Naked men didn't wander into The Corral every night.

The terminator found a match by the pool table, a bearded, craggy-faced biker dressed in leather.

"I need your clothes, your boots, and your motorcycle."

The room erupted in laughter.

The man's eyes narrowed. "You forgot to say please."

Taking a deep draw on his cigar, the biker blew smoke in the stranger's face

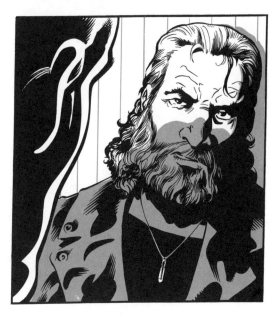

"You forgot to say please."

and ground the cigar into the man's bare chest. It produced no reaction. Instead, the terminator calmly crushed the biker's hand, forcing him to the floor.

Behind him, another biker broke a pool cue on the back of his head. With one hand, the terminator flung the man through the front window, and then tossed the first biker into the bar's

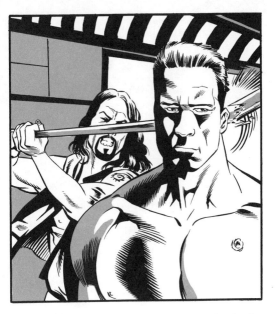

Another biker broke a pool cue on the back of his head.

kitchen. The man landed on the hot iron stove, badly scalding his hands.

Another man stabbed the terminator with a knife. Unfazed, he deftly removed the weapon and impaled the attacker onto the pool table—and the rest of the patrons backed away.

The terminator advanced into the kitchen. The biker was on the floor,

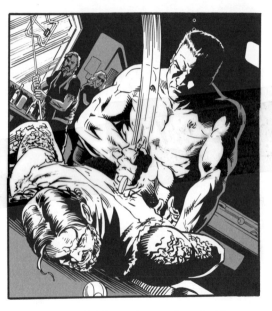

He impaled the attacker onto the pool table.

shaking. He tried to fire his .45 automatic, but the terminator simply took the handgun and held it up, checking its caliber and condition.

The man tossed him his motorcycle keys. He knew what he had to do.

The terminator exited the bar dressed entirely in black leather. He straddled the Harley.

The bar owner emerged and fired a

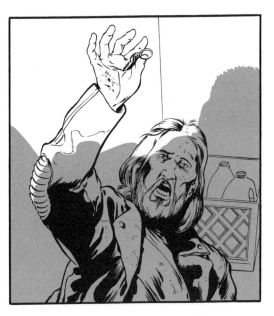

The man tossed him his motorcycle keys.

round in the air from his sawed-off shotgun.

"I can't let you take the man's wheels, son. Now get off before I put you down."

The terminator stopped, swung off the bike, and approached with slow deliberation. What he wanted, he took, and he snatched the gun from the owner's trembling hands.

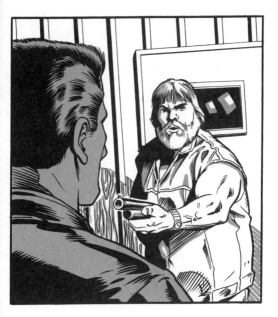

"Now get off before I put you down."

Then the terminator removed a pair of sunglasses from the man's breast pocket and put them on.

Gunning the motorcycle's engine, the terminator peeled out of the parking lot and was gone.

That night, in another part of town, a police officer noticed a strange electrical disturbance near the Sixth Street Bridge underpass. He pulled

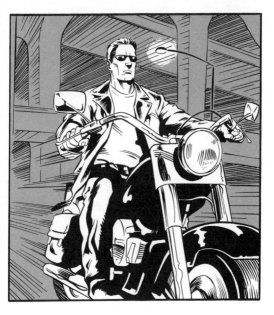

The terminator peeled out of the parking lot and was gone.

over to investigate, sweeping his flashlight over the area.

Then he drew his gun: a large hole, still glowing red, had been burned in a chain-link fence.

As he examined the damage, a man knocked him out from behind. The stranger bent over the unconscious officer, took his gun, and looked around.

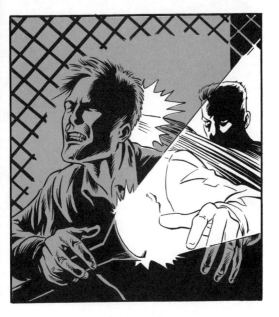

*As he examined the damage, a man
knocked him out from behind.*

He was slim—with sharp, handsome features and gray eyes—and completely naked.

Minutes later, dressed in the officer's uniform, the strange man typed a name into the patrol car's computer: "Connor, John."

The screen displayed the boy's arrest record—trespassing, shoplifting, vandalism—and then listed the address of

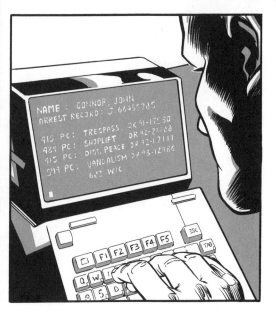

The screen displayed the boy's arrest record.

his legal guardians: Voight, Todd and Janelle, 19828 S. Almond Ave.

The next morning John's foster mother, Janelle Voight, rescued the newspaper from the front yard sprinkler and stopped by the garage on her way back inside.

"John! Get in there and clean up that pigsty of yours."

Her son was fixing his dirt bike with

a friend, and he responded by revving the bike's engine louder.

Exasperated, Janelle stormed into the house, where her husband sat mesmerized in front of the TV.

"Would you get off your butt and help me? Todd?! He hasn't cleaned that room of his in a month."

"Well, if it's an emergency, hang on. I'll get right on it."

Outside, John was on his Honda, ready to leave. Tim hopped on the back.

"John! Get inside and do what your mother tells ya," Todd yelled.

The boy nailed his foster parent with a defiant glare.

"She not my mother, *Todd!*"

John took off, riding across the front lawn and into the street.

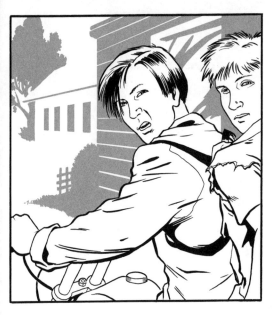

"She's not my mother, Todd."

In the Pescadero State Hospital, Sarah Connor was in the middle of her morning routine, doing pull-ups from her upturned, white metal hospital bed. She huffed rhythmically, sweat beading on her skin.

In the hallway, Dr. Peter Silberman was lecturing a small knot of interns. He was describing Sarah's "unique

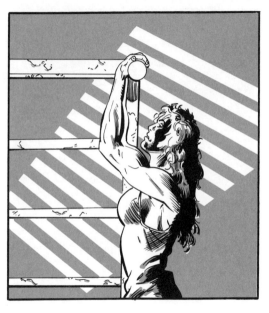

She huffed rhythmically, sweat beading on her skin.

delusional architecture" as they neared her cell.

"She believes that a machine called a terminator, which looks human, of course, was sent back through time to kill her. And also that the father of her child was a soldier sent back to protect her. He was from the future, too."

Dr. Silberman looked in the cell

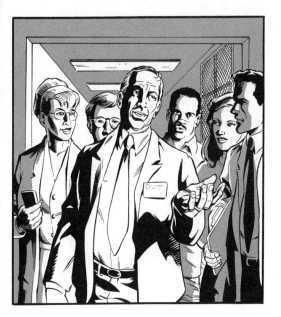

*"She believes that a machine was
sent back through time to kill her."*

door window and switched on the two-way intercom.

"Morning, Sarah."

Sarah stood panting, her long sweaty hair hanging in her face. She regarded her visitors coldly.

"Good morning, Dr. Silberman. How's the knee?"

"Fine, Sarah." Dr. Silberman smiled weakly and turned off the intercom.

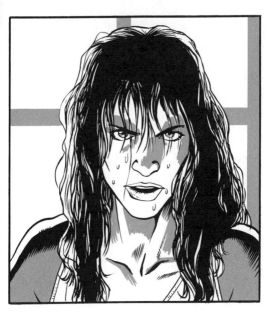

"Good morning, Dr. Silberman. How's the knee?"

"She, uh, stabbed me in the kneecap with my pen a few weeks ago."

Dr. Silberman stepped aside to let the interns peer in. As they did, he approached the head attendant.

"Douglas, see that she takes her thorazine, would you?"

Douglas nodded, and the doctor led his students to the next patient.

Later in the day, the police

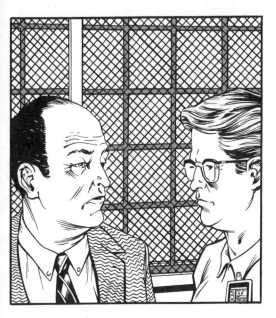

"Douglas, see that she takes her thorazine, would you?"

officer pulled up to the Voights' house and asked to speak with John.

"You could if he were here," Todd said. He was fed up with these police visits.

The officer was polite but evasive about what he wanted. He asked for a photograph of John, and Janelle gave him one.

"There was a guy here this morning

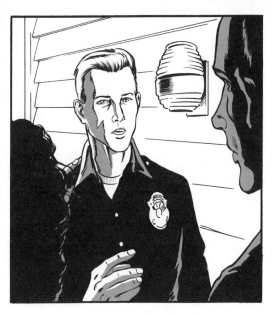

He asked for a photograph of John.

looking for him, too," Janelle said.

"Yeah, big guy. On a bike," Todd added. "Has that got something to do with this?"

The man considered it a moment and then smiled reassuringly.

"No. I wouldn't worry about him. Thanks for your cooperation."

John and Tim approached a deserted automatic teller machine.

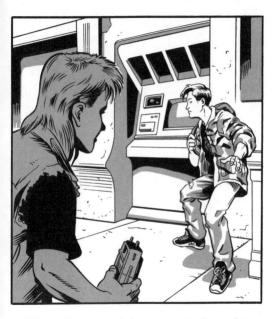

John and Tim approached an automatic teller machine.

"Please insert your stolen card now," John said sarcastically, inserting a card attached by a ribbon wire to a portable computer keyboard. With a few keystrokes, he hacked its PIN number.

"Who'd you learn this stuff from, anyway?" Tim asked.

"From my mom. My real mom, I mean."

The machine obligingly spat out

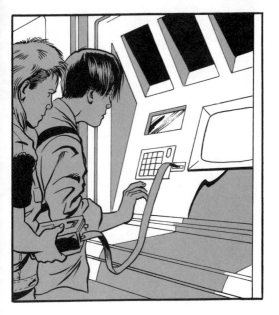

"From my mom. My real mom, I mean."

three hundred dollars. John held up the cash. "Easy money!"

The boys sprinted around the corner to John's dirt bike. As Tim put the computer rig in John's backpack, he noticed a picture and pulled it out.

"That her?"

"Yes."

"She's pretty cool, huh?"

"No. She's a complete psycho. That's

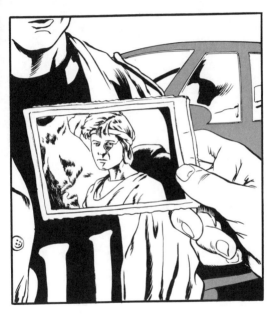

"She's a complete psycho."

why she's up at Pescadero. It's a mental institute, okay? She tried to blow up a computer factory, but she got shot and arrested."

John tried to sound tough. "C'mon, let's go spend some money."

The boys climbed on the bike and sped away.

 Nearby, the terminator cruised

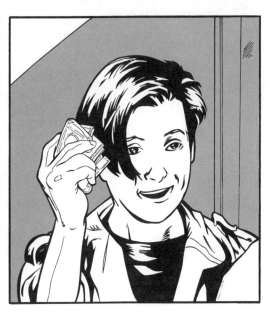

"C'mon, let's go spend some money."

the streets on his Harley, constantly scanning his surroundings.

In the Pescadero observation room, Sarah watched a video of herself being evaluated. On the screen, she rested her chin on her folded arms, her voice barely audible. She was describing her recurring nightmare.

"The children look like burnt paper . . . black, not moving. Then the blast

Sarah watched a video of herself being evaluated.

wave hits them and they fly apart like leaves . . ."

On the tape, Sarah became over-whelmed, but Silberman had been patronizing, as usual.

"I'm sure it feels very real to you—"

"On August 29th, 1997, it's going to feel pretty real to you, too! You think you're alive and safe. You're already dead. Everybody, him, you.

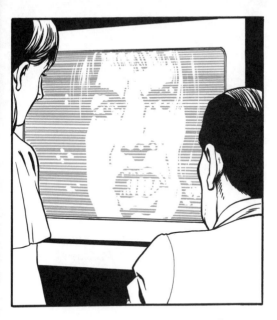

"It's going to feel pretty real to you, too!"

Everything you see is gone! I *know* it happens. *It happens!*"

Silberman paused the tape on Sarah's contorted face.

In the room, she stabbed out her dead cigarette, looking intently at the doctor for the first time. She spoke softly.

"I feel much better now, clearer."

She sat down at the table. He had

promised, if she improved, to transfer her to minimum security, where she could receive visits from her son.

He observed her carefully. "Let's go back to what you were saying about those terminator machines. Now you think they *don't* exist?"

"They don't exist. I know that now. There would have been some evidence."

"So you don't believe anymore that the company covered it up?"

"No. Why would they?"

The Artificial Intelligence Lab at Cyberdyne Systems was a busy place. A lab assistant urgently approached two men hunched over a computer terminal.

"Mr. Dyson? The materials team is

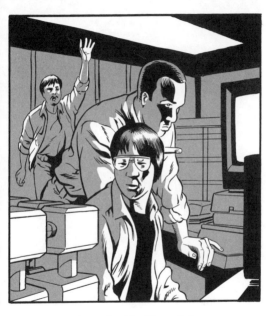

The Artificial Intelligence Lab at Cyberdyne Systems was a busy place.

running another series this afternoon and you have to sign for the, uh . . . it. You have to sign *it* out."

The handsome black man nodded agreeably. It had become a routine task for the star researcher.

Dyson greeted the guard at the lab vault. Both men produced keys that they inserted in dual locks. They

"You have to sign for the, uh . . . it."

turned them simultaneously, and the vault unlatched.

Dyson entered and pressed a wall sensor. A small glass vial emerged from a sealed compartment. Mounted inside was a broken wafer of metal. Dyson took it carefully and paused, stepping up to a bell jar in another compartment.

A small glass vial emerged from a sealed compartment.

Inside gleamed an articulated metal hand and forearm.

The items were a tantalizing riddle. They had appeared one day, pieces of a computerized robot no one knew how to create, and no one would tell him where they came from.

Dr. Silberman's brow furrowed. "You see, Sarah, I know how smart you are, and I think you're just telling

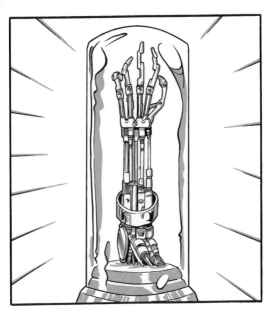

They were pieces of a computerized robot that no one knew how to make.

me what I want to hear. I don't see any choice but to recommend that you stay here for another six months."

Sarah couldn't contain herself any longer. She leapt across the table and strangled Silberman with his tie. Attendants rushed over, pulled her off, and injected her with sodium amytal.

"You don't know what you're doing!" she screamed.

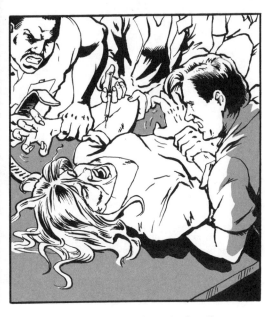

"You don't know what you're doing!"

Meanwhile, John and Tim were taking their favorite shortcut—racing along the dry concrete beds of the city's flood control canals.

As the terminator cruised the canal's overpass, his head snapped right at the sound of a dirt bike's whine. From a fleeting image of the boy's face, he calculated his identity— "Target acquired."

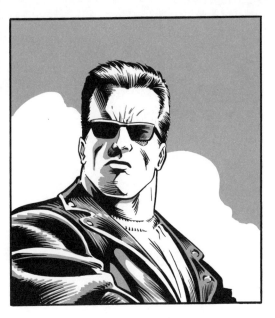

"Target acquired."

The terminator pulled an immediate U-turn, heedless of traffic, and followed them as they exited the canal.

At the same time, the police officer was tracking John by a different method. He showed his photo to two young girls.

"You just missed him," one said. "I think he was going to the Galleria."

Inside the mall, John and Tim

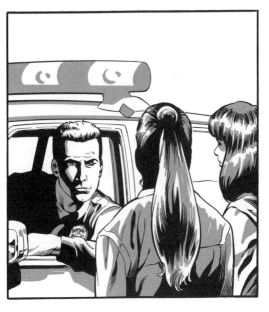

"I think he was going to the Galleria."

had gone straight to the video arcade, where John was enmeshed in an old favorite, Missile Command.

John's pursuers methodically searched each level of the building. The terminator, carrying a box of long-stemmed red roses, scanned the crowd from side to side, while the officer stopped children to show them John's picture.

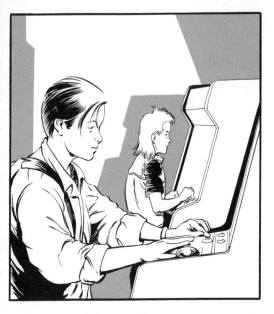

John was enmeshed in an old favorite, Missile Command.

Finally, a teenager pointed him to the arcade.

Tim went to get more quarters. Near the front, the cop stopped him and showed him the picture.

"Naw. I don't know him," Tim lied.

He hustled back to tell John, who was inside a fighter jet simulator.

John looked over, caught the cop's eye, and immediately made for the

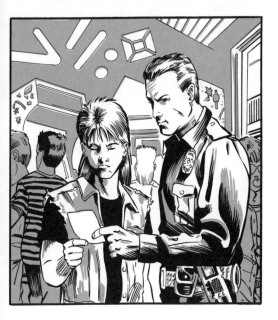

"Naw. I don't know him."

arcade's back door. The officer advanced after him, pushing kids out of the way.

John ran full tilt down the winding service corridor and burst through a fire door. He turned right and came to an abrupt halt, eyes growing wide.

The terminator strode toward him, expressionless. He scattered the box of roses, whipping out the lever-action

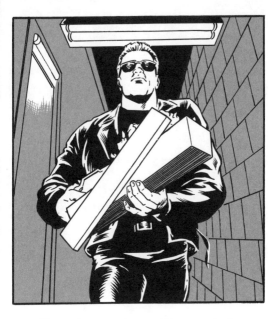

The terminator strode toward him, expressionless.

shotgun and jacking a round into the chamber.

John reversed course in terror. But the police officer appeared at the other end of the hall and drew his gun. John was trapped.

"Get down," the terminator ordered. He fired a shell into the officer's chest and immediately picked up the boy, covering him.

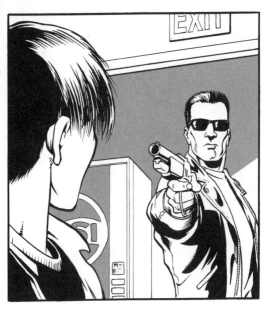

"Get down," the terminator ordered.

The cop straightened and fired an entire clip into the terminator's back.

As the cop reloaded his Beretta, the terminator burst open a locked door with one arm and shoved John inside. He turned and raised his shotgun, unleashing another six rounds, each one driving the officer backward till he collapsed to the floor, apparently

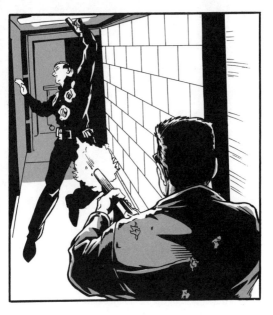

He unleashed six rounds into the officer.

dead. The terminator stood over him, reloading.

John looked out in horror. Each shell had created a rippled, silver puddle in the cop's chest, but now the wounds softened, closed, and disappeared without a trace. The cop got up, unharmed, and grabbed the terminator's weapon.

The two beings wrestled for control

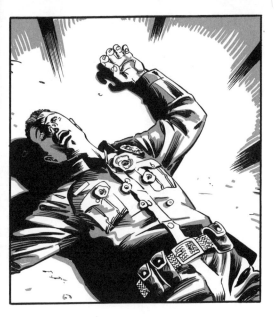

*The wounds softened, closed, and
disappeared without a trace.*

of the gun, throwing each other into the walls with unbelievable force. One wall finally gave in, and they plunged into a clothing store.

John couldn't believe his eyes. He ran, flinging himself down the back stairwell toward the garage.

The cop hurled the terminator through the store's front window, and

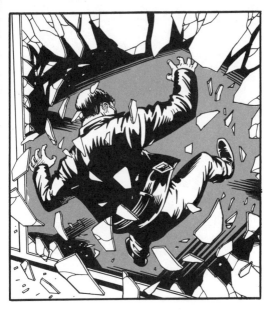

The cop hurled the terminator through the store's front window.

he hit the ground, stunned. Then the cop left him to chase the boy.

As shoppers looked on in amazement, the terminator got up and walked back through the store's broken wall, picking up his discarded shotgun along the way.

John desperately kick-started his bike, but it wouldn't turn over. His hands shook as he adjusted the choke.

John desperately kick-started his bike.

"Come on!" he muttered.

The cop burst out of the stairwell as the bike roared to life. John gunned the engine as hard as he could. The officer ran after him, arms pumping. Somehow, he kept up.

John flew out of the garage and into the street, right into the path of a huge truck cab, which braked and swerved, barely missing him. As John sped off,

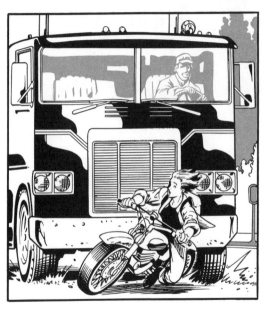

John flew right into the path of a huge truck cab.

the cop jumped onto the still-moving vehicle, threw the driver out, and slid behind the wheel. He recklessly slammed other cars out of the way in his single-minded pursuit.

Behind them, the terminator joined the chase on his Harley.

John abandoned the streets and headed down into the drainage canals. It would be impossible for the truck

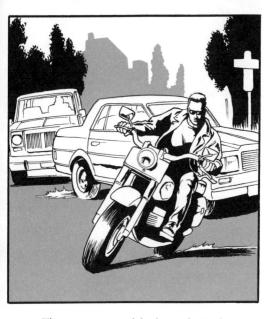

The terminator joined the chase on his Harley.

cab to follow him here, so he slowed to a stop and looked back.

At first, he saw nothing. Then the cab loomed above: it burst through the overpass's concrete guard rail and sailed twenty feet to the bottom, landing in a gut-wrenching crash. It careened wildly, showering sparks, but kept plowing forward.

There was no time to think. John

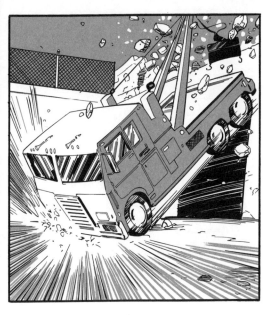

The cab landed in a gut-wrenching crash.

peeled out, racing just ahead, weaving past rusted grocery carts and stripped autos, barely in control.

The terminator followed along a parallel road above the canal, unable to find a way down. From his speeding bike, he shot off the locks from the overpass gate crossings to get through.

John couldn't outrace the bigger machine. He heard a rending screech

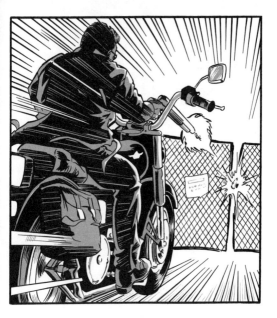

*He shot off the locks from the overpass
gate crossings to get through.*

and looked back hopefully—the cab's roof had been sheared off by a low-hanging overpass. But in the next moment, the police officer sat up, pushed out the shattered windshield, and closed the gap.

The cab bumped the dirt bike once, twice. John screamed—this was the end. But the terminator had found a gap and jumped his motorcycle into

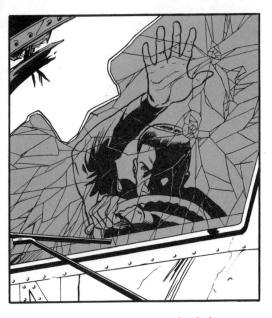

The police officer sat up and pushed
out the shattered windshield.

the air, landing just behind the rumbling truck cab.

The cop tried to keep the terminator from passing, and they jockeyed for position. Seeing a sliver of daylight, the terminator raced ahead and pulled even with John, plucking him off his Honda with one hand.

Next, the terminator shot out the cab's left front tire, and it swerved and

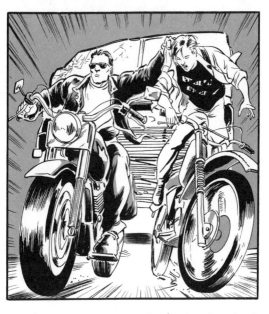

The terminator plucked John off his Honda with one hand.

smashed into an overpass piling, exploding in a cataclysm of flames.

The terminator pulled to a stop, gun drawn, waiting to see if his rival survived the carnage. Only a burning tire rolled out. Satisfied, the terminator drove off with John, who was safely in front of him on the bike.

Minutes later, a chrome figure emerged from the fire. As it walked, its

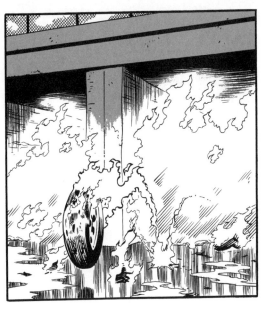

Only a burning tire rolled out.

smooth surface became more defined, recreating the appearance of the cop. When every detail was complete, the silver skin took on the colors of the uniform, the pale skin, the short brown hair—mimicking a human to perfection.

Back on the streets, John had seen enough.

"Whoa. Time out! Stop the bike!"

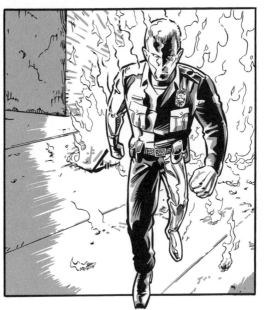

The silver skin took on the colors of the uniform.

Without a word, the terminator pulled off the main road and into a deserted alley. It was late afternoon—but a lifetime had passed.

He knew. His mother had told him, along with a thousand other things he didn't believe.

"You are a terminator, right?" John asked.

"You are a terminator, right?"

"Yes. Cyberdyne Systems, Model 101."

John touched one of the many holes in his leather jacket. "Holy shit. You're really real! You're like a machine underneath, right?"

"I'm a cybernetic organism. Living tissue over a metal endoskeleton."

Terminator's voice was flat, emotionless. John poked his face incredulously

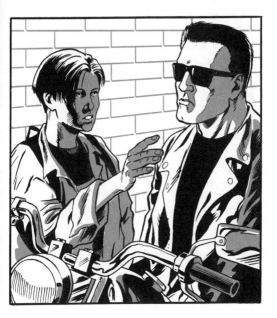

*"I'm a cybernetic organism. Living
tissue over a metal endoskeleton."*

while the cyborg reloaded the shotgun.

"My mission is to protect you."

"Who sent you?"

"You did. Thirty-five years from now you reprogrammed me to be your protector here, in this time."

John shook his head. It wasn't real. It couldn't be.

Night fell as they drove along the highway.

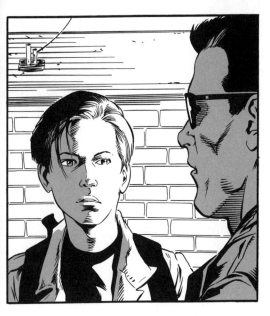

"My mission is to protect you."

"So this other guy? He's a terminator like you, right?" John asked.

"Not like me. A T-1000. Advanced prototype. Mimetic polyalloy. Liquid metal."

John wanted to go home, but Terminator refused: the T-1000 would definitely pursue him there next. But John made Terminator stop so he could at least call and warn his foster parents.

"Advanced prototype. Mimetic polyalloy. Liquid metal."

They pulled up to a phone booth in a liquor store parking lot. Janelle answered the phone. She sounded fine, a little too fine.

"It's late," she said. "I was beginning to worry. If you hurry home, we can have dinner together."

John put his hand over the receiver. "Something's wrong. She's never this nice."

Janelle sounded fine, a little too fine.

"Where are you?" Janelle asked.

In the background, John could hear the dog barking. His father yelled at the dog to be quiet, but then he was suddenly silent.

"John, honey, are you okay?"

Terminator took the phone and, imitating John's voice, said, "I'm right here. I'm fine."

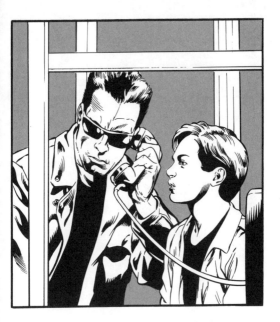

Terminator took the phone and imitated John's voice.

"What's the dog's name?" he whispered to John.

"Max."

Terminator asked, "Hey Janelle, what's wrong with Wolfy?"

"Wolfy's fine, honey. Where are you?"

He hung up immediately.

"Your foster parents are dead."

Back in John's house, Janelle retracted her bladelike arm. Todd,

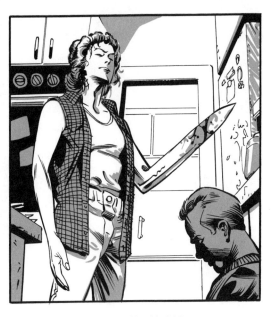

Janelle retracted her bladelike arm.

pierced through the skull, slumped dead to the floor.

The T-1000 morphed from Janelle back to the police officer and left the house.

John was stunned. Terminator explained that the T-1000 was capable of imitating any object it touched of a similar size.

"It can't form complex machines,"

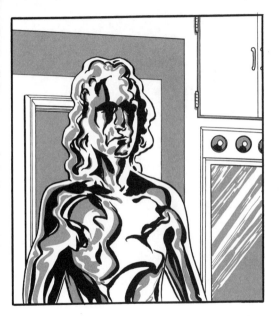

The T-1000 morphed from Janelle back to the police officer.

he said. "It can form solid metal shapes. Knives and stabbing weapons."

That night in the hospital interview room, detectives were showing Sarah two sets of pictures. The first were black-and-white photos from the 1984 police station massacre; the second were color photos taken at the mall that afternoon. In each was the same lifeless face.

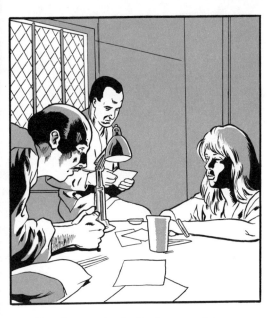

Detectives were showing Sarah two sets of pictures.

"We know you know who this guy is," Detective Weatherby pleaded. "Doesn't that mean anything to you? Don't you care?"

Sarah was lost in shock, withdrawn. She wouldn't respond, even when a hand was waved in front of her face.

"We're wasting our time," Detective Mossberg said. "Let's go."

As they got up, Sarah slipped a

"We're wasting our time."

paperclip from a photo and hid it in her fingers unnoticed, then she let herself be escorted back to her cell.

John sat on the hood of a parked car. He couldn't believe his mother had been right all along, that all the crazy things she'd said while he was growing up were true.

"Listen. We gotta get her out of there."

"Listen. We gotta get her out of there."

"Negative," Terminator replied. Most likely, the T-1000 would copy Sarah next.

"And what happens to her?"

"Typically, the subject being copied is terminated."

"Why didn't you tell me? We gotta go right *now!*" John hopped off the car, but the terminator grabbed his jacket.

"Hey, what's your problem?" John

"Typically, the subject being copied is terminated."

struggled to get free, but the machine wouldn't let go—she wasn't a priority.

The boy screamed for help, finally blurting out, "Let me go!"

Terminator released his grip automatically, and John tumbled to the ground.

"Why the hell did you do that?" John yelled.

"Because you told me to."

"Why the hell did you do that?"

John stared in amazement, getting up from the ground slowly.

"You have to do what I say, huh?"

"That is one of the mission parameters."

John tested the theory by ordering the cyborg to stand on one leg. When he did, John shouted with glee. "Cool! My own terminator!"

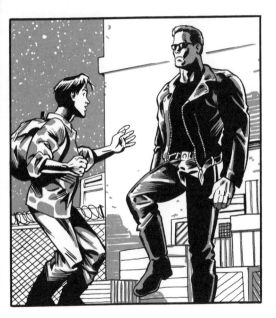

"Cool! My own terminator!"

Two muscle-bound guys came over to see if John really needed help.

"Take a hike, bozo," John said.

One guy got in his face. "What? Screw you!"

John moved closer to his new guardian. "Grab this guy," he gleefully instructed.

Terminator obediently lifted the man by his hair, and John happily taunted

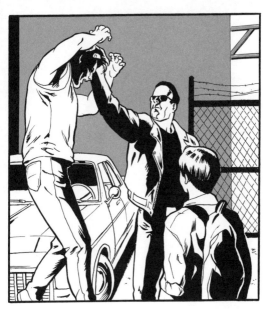

"Grab this guy."

the bully. But when the other guy tried to wrestle the terminator off, the cyborg broke his hand, threw him down, and whipped out his .45 automatic.

"No!" John screamed, deflecting the weapon as it fired. "Put the gun down!"

Terminator complied, and the two men ran away.

"You were gonna kill that guy!" John yelled.

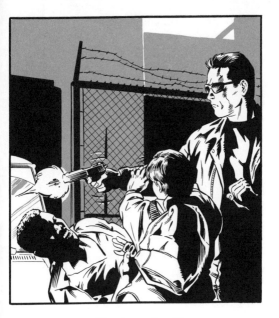

"Put the gun down!"

"Of course. I'm a terminator."

John finally understood.

"Listen to me, very carefully," he said, "you just can't go around killing people."

"Why?" Terminator asked.

"'Cause you can't!"

"Why?" it insisted.

"You just can't, okay? Trust me on

"You just can't go around killing people."

this. Look, I'm gonna go get my mom. And I *order* you to help me."

Terminator followed without a word of protest.

At Pescadero State Hospital, a police car was let through the gate without question.

Inside the hospital, Douglas was strapping Sarah tightly to her bed. Emboldened by her blank expression,

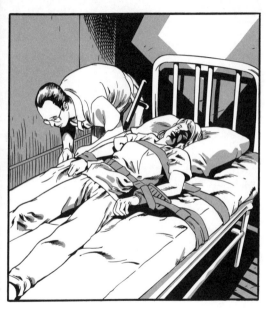

Douglas was strapping Sarah tightly to her bed.

he bent down, admiring her, and tongued her face.

After Douglas left, Sarah's eyes focused again. She spat the paperclip to where her hand could reach it, unlocked her bindings, got up, and began working on the cell door.

Disguised as the cop, the T-1000 entered the hospital and asked for Sarah, then mysteriously disappeared.

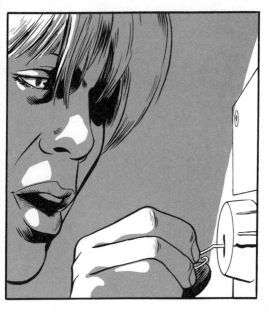

Sarah began working on the cell door.

The detectives were through for the evening, and Lewis, the night guard, was letting them out. After locking the door, Lewis went to buy coffee from the dispenser near the nurse's station.

As Lewis waited, the T-1000, disguised as the black-and-white floor tiles, rose up behind him and assumed the guard's shape.

Lewis turned around and stopped in

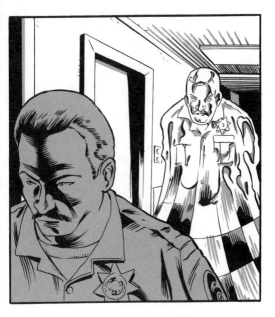

The T-1000 rose up behind him.

shock before his doppelgänger, which pointed a finger at Lewis's forehead. In a flash, the finger elongated into a narrow spike, puncturing the guard's eye socket and killing him bloodlessly.

The T-1000 dragged the dead guard to a closet, took his gun, and entered the asylum to begin "rounds."

Douglas was in the middle of bed checks when he stopped to

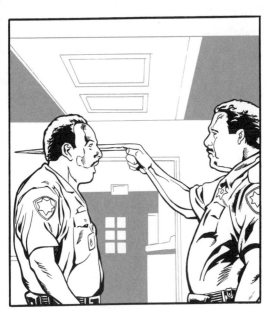

The finger elongated into a narrow spike.

investigate an unlocked supply room. As he did, Sarah surprised him from behind and bludgeoned him across the face with a broken mop handle. She hit him till he slumped unconscious to the floor.

Sarah took his keys and nightstick. Then, swift and silent, she sprinted down the hall, her mind now fully alert.

She snuck up on Dr. Silberman and

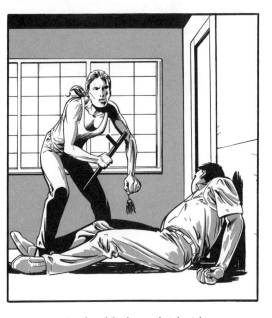

Sarah took his keys and nightstick.

another attendant, bringing the second man down with a few well-placed blows with the nightstick. Then she broke Silberman's arm as he reached for the phone.

After tranquilizing the attendant, she hauled out a jug of drain cleaner and filled the empty hypodermic needle.

Silberman's face went white. "What are you gonna do?"

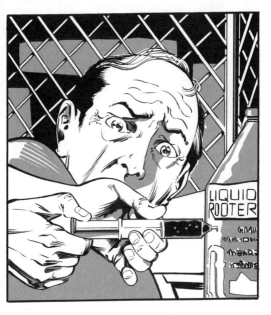

"What are you gonna do?"

John and Terminator stopped outside the hospital. Once again, John ordered Terminator not to kill anyone. Then he made him *swear* he wouldn't kill anyone. Finally satisfied, he let the cyborg approach the gate.

As the guard came out, Terminator shot him in both legs.

"What the hell are you doing?" John yelled.

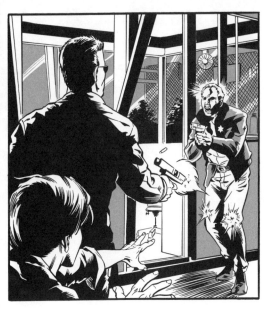

"What the hell are you doing?"

Terminator activated the gate control and returned to the bike.

"He'll live."

They drove inside.

Sarah approached the floor's security checkpoint, holding the deadly syringe to Dr. Silberman's neck.

"Open it or he'll be dead before he hits the floor."

The attendants refused, but Dr.

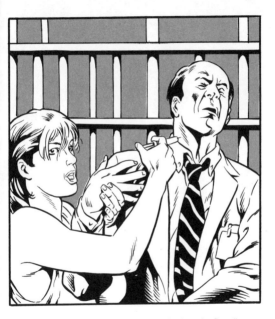

"Open it or he'll be dead before he hits the floor."

Silberman pleaded with them to cooperate. He knew she was serious.

Reluctantly, they let her through. She guided Silberman into the far hall. There, an unseen orderly jumped her, removing the syringe in one motion. Sarah pushed the man away and took off, attendants chasing after her. She unlocked one door and raced ahead to a second barred gate. After going

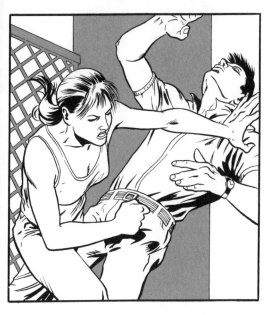

Sarah pushed the man away and took off.

through, she broke the key off in the lock, stranding her pursuers on the other side.

As Sarah ran for the elevators, one opened, and she eagerly jogged toward it. Then time stopped: the terminator strode out, armed and unhurried, and swiveled his head in her direction.

Sarah slipped to the floor at the feet

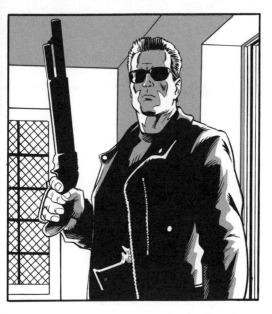

The terminator strode out, armed and unhurried.

of her nightmare. Terror blacked out every thought but flight. She scrambled up and ran back heedlessly, not hearing her son call out.

Pursuing attendants tackled her to the floor.

"He'll kill us all!" she screamed over and over, flooded with panic as the terminator approached.

The cyborg threw the attendants off

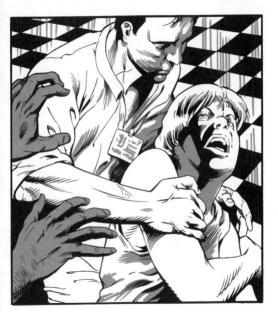

"He'll kill us all!"

of her like rag dolls. John appeared at her side out of nowhere.

"Mom, are you okay? *Mom!!*" His voice finally broke through. "It's okay, Mom. He's here to help."

Terminator held out his hand. "Come with me if you want to live."

Sarah couldn't comprehend what was happening, but the terminator

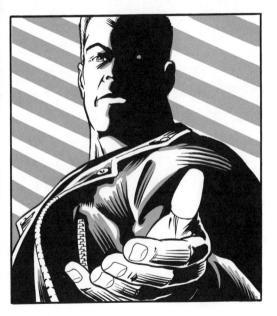

"Come with me if you want to live."

hadn't killed her—or her son. She let herself be helped up.

The police officer approached on the other side of the locked gate, his face stern. He stepped forward, and the bars passed through his body, but his gun caught. He turned it sideways and slipped it through.

"Go," Terminator ordered, then he blasted the T-1000 with his shotgun.

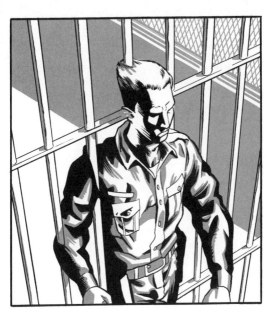

The bars passed through his body but his gun caught.

Terminator followed Sarah and John into the elevator, which closed just in time. Then a silver broadsword shot between the doors, morphed into two crowbar arms, and forced the elevator back open.

Terminator fired again, splitting the T-1000's head in two. It fell back, and the doors shut. They began to lower.

"What the hell is it?!" Sarah yelled.

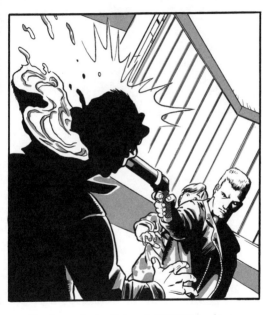

Terminator fired, splitting the T-1000's head in two.

Something landed on top of the elevator car, then a sword arm punched blindly through the ceiling.

"Get down!" the cyborg said, firing his shotgun.

Sarah grabbed Terminator's .45 and began shooting as well. As the sword arm stabbed repeatedly into the car, it glanced once off Sarah's right shoulder. Finally, they reached the bottom.

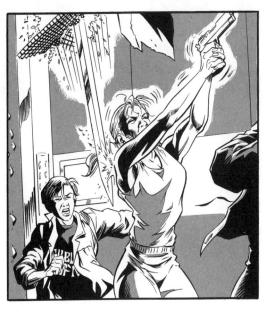

The sword glanced once off Sarah's right shoulder.

In the underground garage, Sarah stopped a patrolling police car. She fired a warning shot and ordered the officer out.

The T-1000 poured into the elevator, reformed itself, and began running after the automobile, which peeled out backward just ahead of him. Without time to turn around, Terminator drove up the circular exit ramp as he and

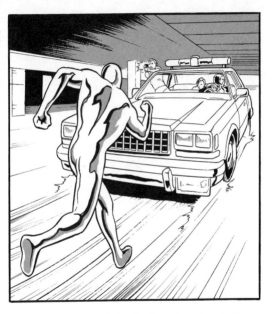

The automobile peeled out backward just ahead of him.

Sarah pumped ammo into the T-1000. John, well-trained by his mother, kept their weapons loaded.

The patrol car reached the street and wheeled around. Using thick hook arms, the T-1000 jumped and caught the car's trunk as it sped off.

The T-1000 climbed up and smashed the rear window, swinging for John. Sarah took the wheel, and

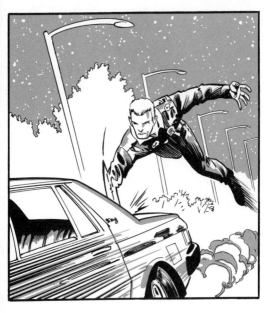

The T-1000 caught the car's trunk as it sped off.

Terminator stood up in the open driver's-side window and fired his twelve-gauge. The first shot broke a metal arm. The second shot knocked the machine off, and the T-1000 rolled helplessly to a stop on the asphalt.

As they accelerated away, the broken hook rattled in the trunk. Afraid it might spring to life, John reached out and flung it off.

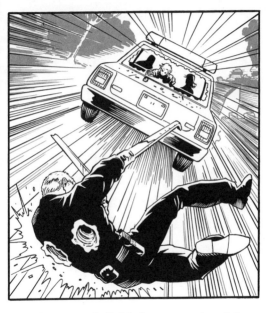

The T-1000 rolled helplessly to a stop on the asphalt.

The T-1000 walked up the street. When it reached its missing piece, the hard metal liquified and melted into its shoe. Then it walked back, calculating its next move.

Terminator turned off the head-lights as they sped down the dark road; it didn't need them.

"Are you alright?" Sarah asked John, reaching for him.

The hard metal liquified and melted into its shoe.

"Yeah," he said. She felt her son for injuries.

"I said I was okay," he protested.

"It was stupid of you to go there," Sarah scolded him. "You almost got yourself killed. You cannot risk yourself, even for me, do you understand?"

"I had to get you out of that place . . ."

"I didn't need your help. I can take care of myself."

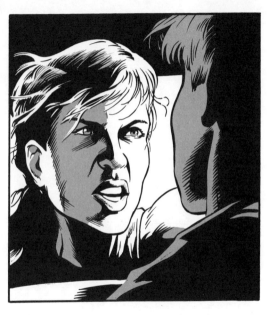

"You cannot risk yourself, even for me, do you understand?"

John turned away. He had started to cry.

That night, the trio found shelter in a darkened filling station garage.

First, Terminator sewed up the gash on Sarah's shoulder, then she ministered to his injuries, pulling dozens of flattened bullets from beneath his skin with a pair of needle-nose pliers.

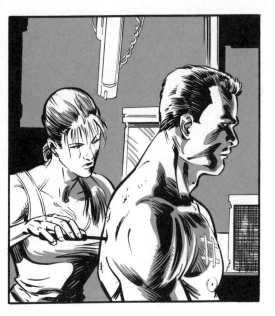

Sarah ministered to his injuries.

Like human flesh, Terminator's skin would heal, but he didn't feel pain.

"Can you learn?" John asked. "So you can be more human?"

He could. "The more contact I have with humans, the more I learn."

At dawn, John and Terminator went searching for a more inconspicuous set of wheels. Finding a station wagon, the cyborg broke the steering

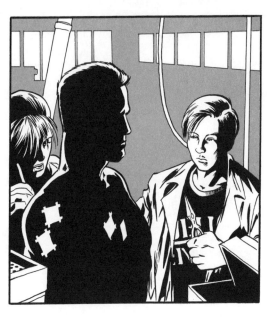

"The more contact I have with humans, the more I learn."

column with one hand and started the car.

John flipped down the visor, and the keys tumbled out.

He held them up for his friend. "Are we learning yet?"

They all drove south along a sparsely traveled desert highway. It was hot, and John was getting tired of Terminator's stiff manner.

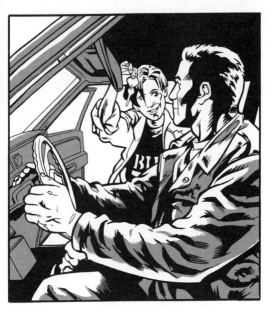

"Are we learning yet?"

"No, no, no. You gotta listen to the way people talk," John said. "You don't say, 'Affirmative.' You say, '*No problemo.*' And if you wanna shine them on, it's '*Hasta la vista, baby.*'"

Terminator repeated the phrase unconvincingly.

"That's great! See, you're getting it."

"*No problemo.*"

Later, they stopped to get food

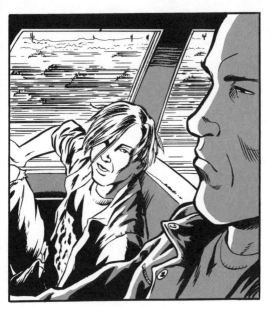

"You don't say, 'Affirmative.' You say, 'No problemo.'"

and gas at a dusty roadside cafe. Sarah ate in the car, lost in thought.

John, bored, went to help Terminator put more coolant in the overheating radiator. Nearby, two kids pretended to shoot each other with toy guns. They argued and wrestled for the weapons.

The scene gave John chills. "We're

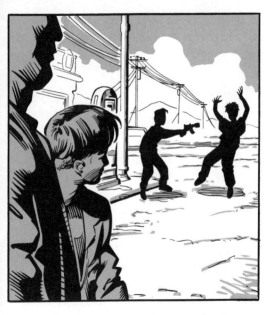

"It is in your nature to destroy yourselves."

not gonna make it, are we? People, I mean."

"It is in your nature to destroy yourselves."

John nodded quietly. "Yeah. Major drag, huh?"

Back on the road, Sarah questioned the terminator about Skynet.

Terminator said that in a few months Miles Dyson at Cyberdyne

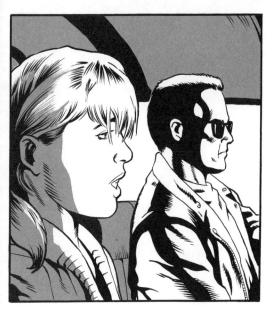

Sarah questioned the terminator about Skynet.

Systems would create a new type of microprocessor that would revolutionize military computer systems. In three years, the automated Skynet strategic defense system would be put into place. Once on-line, Skynet would learn at a geometric rate, soon becoming self-aware.

"In a panic, they try to pull the plug."

"Skynet fights back," Sarah said,

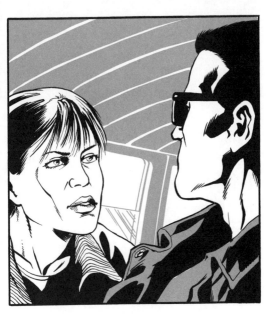

"Skynet fights back."

suddenly understanding.

Skynet would trigger a worldwide nuclear holocaust to save itself from human beings.

Sarah led them to a makeshift camp near the Baja border. It was nothing but a few deserted trailers, a satellite dish, and a stripped Huey helicopter.

Sarah got out and called for Enrique, who jumped out of hiding,

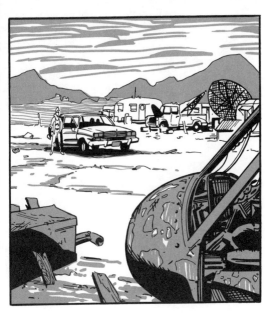

Sarah got out and called for Enrique.

armed and wary. Then he recognized his friend and greeted her fondly. He called for his family to come out.

Enrique offered Sarah some tequila. She took a swig.

"I just came for my stuff. I need clothes, food, and one of your trucks. You two," she said, indicating John and Terminator. "You're on weapons detail."

"You two, you're on weapons detail."

Terminator uncovered Sarah's weapons cache: a narrow cinder-block room chockfull of armaments and explosives.

The cyborg picked up an M-79 grenade launcher. "Excellent."

Then he hefted an enormous six-barreled minigun, a Vietnam-era relic, and his faced twitched in the approximation of a grin.

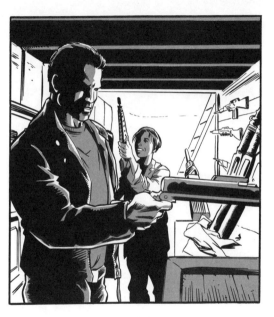

"Excellent."

John approved. "That's definitely you."

Later, Terminator lay underneath Enrique's Bronco fixing the starter motor. John stayed with him, ostensibly to help, but mostly he talked about his mother and her succession of loser boyfriends.

"I wish I could've met my real dad," he said.

"I wish I could've met my real dad."

"You will."

"Yeah. I'm, like, forty-five, I think. I send him back through time to 1984. It messes with your head."

John looked over at Sarah, who was cleaning an automatic rifle. She was dressed in an olive T-shirt, fatigue pants, and aviator sunglasses.

"She still loves him, I guess. I see her crying sometimes."

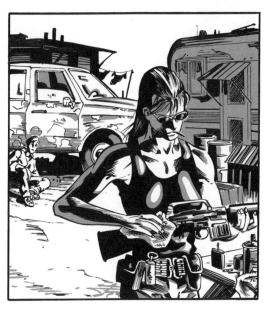

"She still loves him, I guess. I see her crying sometimes."

"Why do you cry?" Terminator asked. "Pain causes it?"

"No. It's when there's nothing wrong with you but you hurt anyway. You get it?"

Terminator crawled from beneath the truck. "No." He turned the key in the ignition, and it started.

"Alright! My man!" John cheered.

 Sarah watched as John taught the

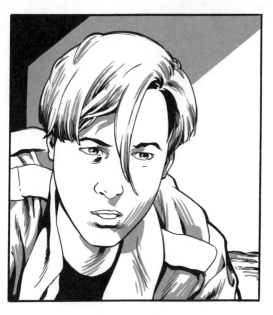

*"It's when there's nothing wrong
with you but you hurt anyway."*

machine to "high five." It was strange to see him bond with a terminator, but in some crazy way it was the best thing. Unlike humans, a terminator would never leave him and never hurt him.

As the sun set, John and Terminator loaded the Bronco. Sarah sat at the picnic table, carving into it distractedly. She lay her head down, feeling, for a brief moment, safe.

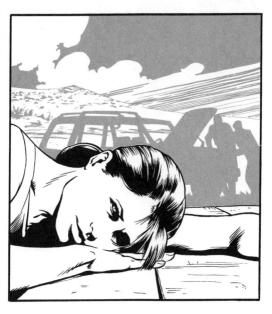

She lay her head down, feeling, for a brief moment, safe.

She fell asleep and began to dream.

Dressed in military gear, Sarah approached a playground full of laughing children. She grabbed the chainlink fence; she had to warn them.

She shouted soundlessly for them to run.

In the park was a vision of herself—younger, happy, playing with her boy.

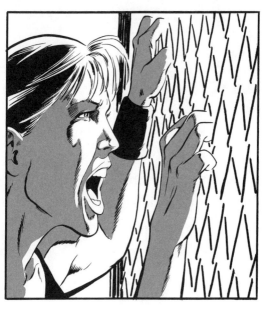

She shouted soundlessly for them to run.

She shook the fence desperately, screaming.

Then came the flash and burning wind, igniting everything in all-consuming flames. The bomb's explosion leveled the distant city and scattered the children's ashes.

Sarah jolted awake, heart pounding. It was still dusk. Enrique's

Sarah jolted awake, heart pounding.

kids were playing with their dog, and his wife was helping her baby to walk.

She looked down at the words she had carved: No Fate.

She wasn't going to wait until dark, and she wasn't going to Mexico.

Grabbing an automatic rifle and a weapon bag, she got in the station wagon and drove off alone.

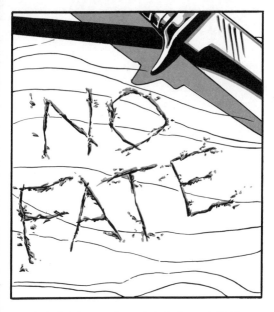

She looked down at the words she had carved: No Fate.

"Wait!" John yelled, but he was too late.

John quickly figured out what she was going to do: kill Dyson and change the future.

Frantic, he convinced Terminator to follow her back to Los Angeles despite the danger.

"The T-1000 might anticipate this move," Terminator said as he drove.

"The T-1000 might anticipate this move."

"I don't care," John said. "We've gotta stop her."

"Killing Dyson might actually prevent the war."

"I don't care! Haven't you learned anything yet? Haven't you figured out why you can't kill people?"

The terminator looked at the boy— he hadn't.

 Tarisa Dyson was trying to get

"Haven't you figured out yet why you can't kill people?"

her son to bed, but Danny eluded her. He raced his remote-control truck up to his father's study. As always, Dad was glued to his computer.

Danny ran his truck into his father's foot. As Miles bent down, scolding him, a bullet burst through the plate glass and smashed the computer screen. Another just missed. Miles dove for cover.

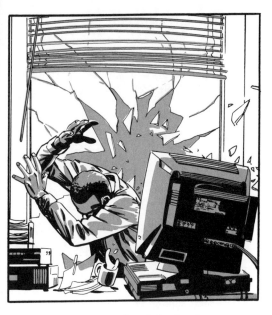

*A bullet burst through the plate glass
and smashed the computer screen.*

In the backyard, Sarah flipped her rifle to automatic and raked the office.

"Daddy!"

"Just go, Danny. *Go!!*"

Sarah exhausted the rifle and broke into the house, drawing her .45, her face expressionless.

As Dyson dodged, Sarah shot him in the shoulder. Havoc erupted as his wife and son ran to him in the living room.

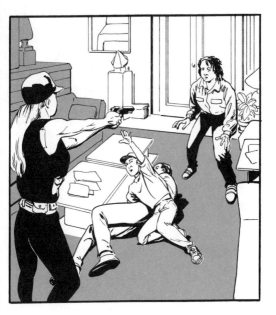

As Dyson dodged, Sarah shot him in the shoulder.

"Shut up! Don't move!" Sarah shouted, her features twisted with rage.

She held the gun inches from his face. She had to kill this man. The cold logic of the future demanded it.

"It's all your fault. I'm not going to let you do it."

Dyson shook with pain and terror, and for a brief second Sarah saw herself through his eyes. She remembered

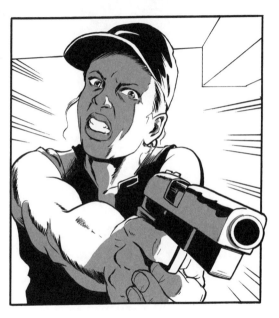

"It's all your fault. I'm not going to let you do it."

the first time she'd had that feeling. Trembling, she lowered the weapon and backed away.

Just then, John and Terminator rushed in the front door.

John crouched by his mother, while Terminator tended to Dyson's wound.

As John held her, Sarah began to cry. "You came here to stop me?"

"Yeah. I did."

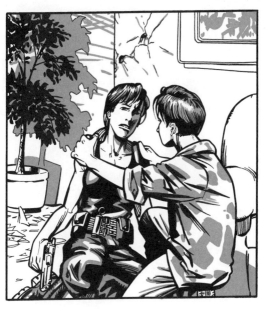

"You came here to stop me?"

"I love you, John. I always have."

"I know."

Dyson was on the verge of hysterics. "Who are you people?"

"Show him," John said, handing Terminator a switchblade and escorting Danny from the room.

Terminator cut the flesh on his left forearm and peeled it off like a ripe

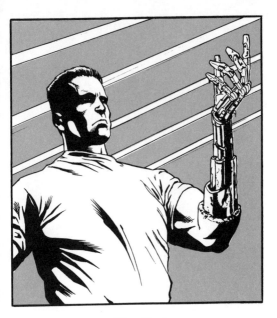

"Show him."

banana skin. He held up an articulated metal hand for them to see.

"Now listen to me very carefully," he began.

The terminator explained everything to Dyson—Skynet, Judgment Day, the future war, and how the invention of his processor would start it all. Considering the circumstances, he took it pretty well.

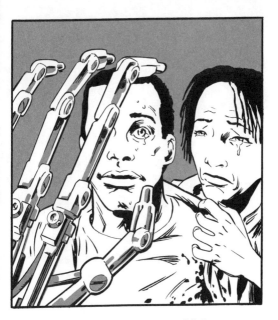

"Now listen to me very carefully."

Dyson was easily convinced of the obvious: they had to destroy everything, all his files at home, at the lab . . . and "the chip," he said suddenly. "Do you know about the chip? They keep it in the vault at Cyberdyne."

"The CPU from the first terminator," the terminator said.

"It was smashed, didn't work. But it

"Do you know about the chip?"

gave us ideas, things we would have never—"

Dyson stopped in midsentence. It all clicked into place: without the first terminator, there would have been no Skynet.

Later that evening, Dyson entered Cyberdyne's main lobby and approached the night guard, followed

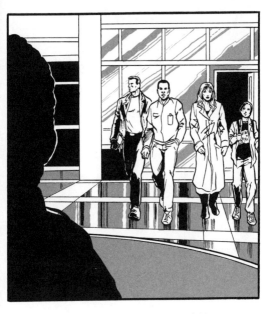

Dyson entered Cyberdyne's main lobby.

by his three "out-of-town" friends. He said he wanted to give them a tour.

"Mr. Dyson, you know the rules. I need written—"

Two guns instantly appeared, ending the speech. They tied up the guard and went to the second floor, using Dyson's security card to access the electronic locks.

When the second night guard

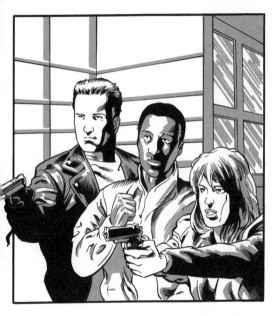

Two guns instantly appeared, ending the speech.

found his partner handcuffed to a bathroom stall, he tripped the silent alarm, sealing all the doors. Then he called for help—lots of it.

The team was just outside the lab when all the locks froze. Dyson panicked, but they weren't going to leave now.

John hooked his computer keyboard up to Dyson's security card—he

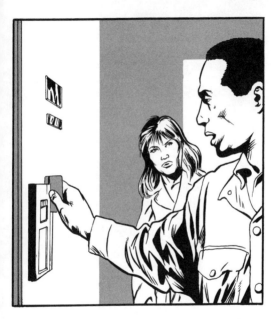

The team was just outside the lab when all the locks froze.

would hack the code for the cabinet where the second vault key was kept.

Meanwhile, Terminator snapped open the breech of his M-79, popped in a grenade, and blew open the lab door.

Terminator retrieved gas masks for Sarah and Dyson to use while the halon fire-control system cleared. Then they went to work.

 At Dyson's deserted house, the

Terminator blew open the lab door.

T-1000 arrived and walked through the researcher's destroyed office. Outside, a pile of computer printouts burned in a metal trash can.

A dispatch came over the police radio. "All units in the vicinity. 211 in progress, the Cyberdyne building. Suspect one is white female, identified as Connor, Sarah..." Like any good

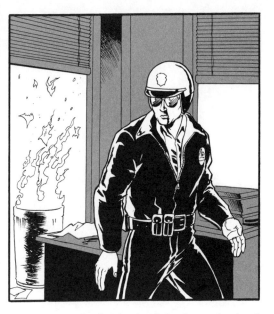

"Suspect one is white female, identified as Connor, Sarah . . ."

cop, the T-1000 responded in an emergency.

John broke the lock code and nabbed the vault key. Then the stab of a helicopter searchlight brightened the room. He checked the exterior video monitor: outside, dozens of black-and-whites and several SWAT vans were gathering—almost the

The stab of a helicopter searchlight brightened the room.

entire LAPD, it seemed. He went to the lab to warn the others.

Things were almost ready—claymore mines had been taped to gasoline drums and rigged to a remote-control detonator.

"I'll take care of the police," the Terminator said, shouldering the enormous minigun.

"Hey, you swore!" John yelled.

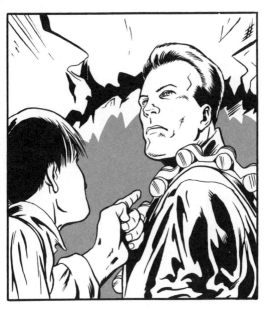

"Hey, you swore!"

He looked back. "Trust me."

The terminator kicked a desk through the plate-glass front entrance. Then he opened fire with the six-barrel minigun, strafing the police cars one by one into useless piles of junk.

Men ran for their lives, jumping behind whatever cover they could find. When the minigun's ammo belt

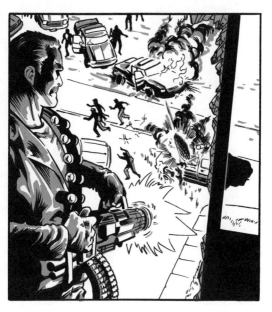

He opened fire with the six-barrel minigun.

was finished, Terminator fired two M-79 grenades for good measure.

He scanned the quiet parking lot. "Human casualties: 0.0."

Dyson and John entered the lab vault. John smashed the glass cases to the floor and retrieved the pieces of the first terminator. He put the chip in his pocket and the hand in his backpack.

In the lab, everything was finished.

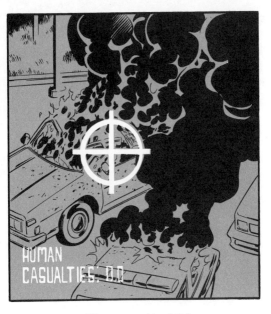

"Human casualties: 0.0."

John and Terminator headed out, and Dyson grabbed the detonator.

Just then, a SWAT team burst through the rear lab door.

Sarah dove instinctively for cover, but Dyson just stood there as the police riddled him with bullets.

Dyson fell behind a cabinet, mortally wounded but still holding the device. Sarah caught his eye. He understood.

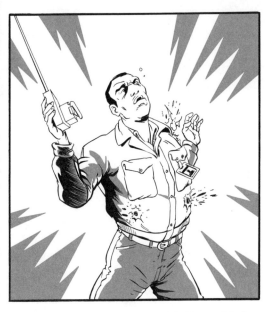

Dyson just stood there as the police riddled him with bullets.

With John safe, Terminator busted through the lab wall and pulled Sarah out. They ran for the elevator and got in.

The tactical force spread out. They found Dyson on the floor, hyperventilating as he died, holding a broken piece of the prototype processor over the detonation trigger.

The men had barely enough time to

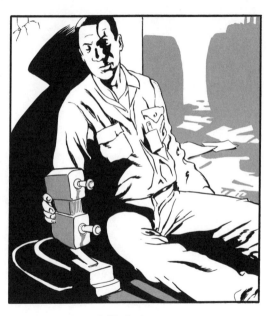

*Dyson held a broken piece of the
prototype over the detonation trigger.*

get clear before Dyson's heart gave out and his arm fell.

Then the second-floor lab disintegrated in an ear-shattering fireball.

Everyone outside cowered from the blast just as the T-1000 rode up on a police motorcycle. It looked like it wasn't too late.

The elevator reached the lobby. As the terminator emerged, the SWAT

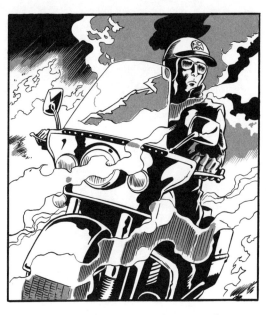

The T-1000 rode up on a police motorcycle.

team fired tear gas. Sarah and John clenched their eyes and shared a gas mask to protect themselves.

"Stay here," Terminator said. "I'll be back."

The cyborg strode toward the entrance as a hail of bullets picked off his flesh. He methodically shot each officer in the leg, disabling them, then

"Stay here. I'll be back."

fired several rounds of tear gas outside, incapacitating everyone else.

He got in the SWAT van and found the keys on the visor. He raced the engine and drove the van through the building's shattered glass front. John and Sarah jumped in, and Terminator squealed out across the parking lot.

The T-1000 had ridden its motorcycle up the staircase and into

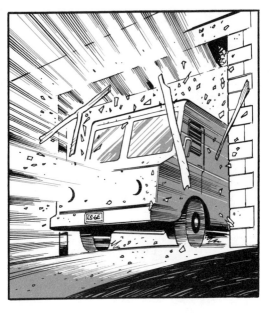

He drove the van through the building's shattered glass front.

the devastated second floor. When it saw the van escaping, it knew who must be inside.

Seeing the police helicopter flying by, the T-1000 decided it was time for a change. It accelerated out of the building and intercepted the chopper in midair.

The machine head-butted the Plexiglas canopy and poured itself through

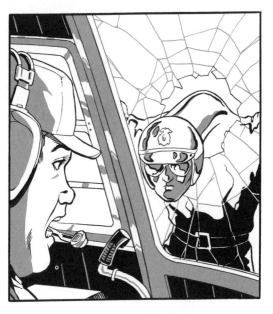

The machine head-butted the Plexiglas canopy.

the smashed opening, reforming in the empty passenger seat.

Still chrome, it turned to the terrified pilot. "Get out."

The pilot did, falling two stories to the ground.

Sarah buried John under a pile of Kevlar vests. Terminator had reached the highway, but the low-flying helicopter was approaching fast.

"Get out."

Sarah fired short blasts at it from an M-16, protecting herself behind one of the van's rear doors.

The T-1000 grew two more arms to handle all its tasks—firing back, reloading, and flying at the same time. Sarah caught a bullet in the thigh. She screamed and fell back, an exposed target.

Terminator slammed on the brakes,

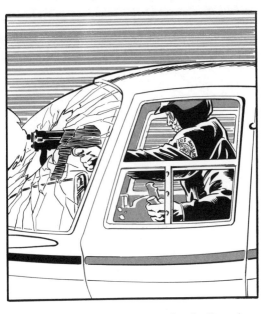

The T-1000 grew two more arms to handle all its tasks.

and the helicopter smashed into the van. Then he pulled away as the chopper crumpled in a fiery heap.

But less than a mile away, a twisted fender punctured a front tire, and the van toppled over and crashed.

John helped his mother from the wreck. She grabbed another rifle, while Terminator commandeered an

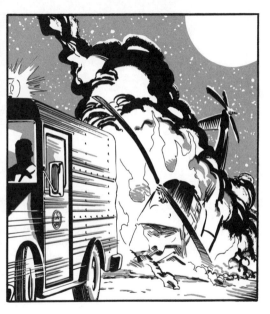

The chopper crumpled in a fiery heap.

old pickup. A far-off noise caught their attention.

Over the rise, a tanker truck carrying liquid nitrogen barreled toward them—and behind the wheel was the T-1000.

They sped off in the pickup, but the worn-out vehicle could barely do sixty. The tanker quickly overtook it

Behind the wheel was the T-1000.

and bumped it into the guardrail, threatening to crush it like a toy.

Sarah wrapped her wounded leg in a tourniquet.

"Drive a minute," Terminator told John.

Leaning out the window, the cyborg blasted the tanker's front grill with an M-79 grenade. It did little damage.

"Take the off-ramp," he instructed.

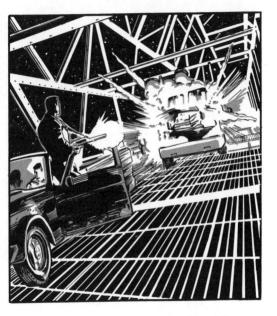

*Leaning out the window, the cyborg blasted the
tanker's front grill.*

The exit road led directly to a steel mill. The semi rammed the pick-up again, causing Terminator to drop his last grenade into the truck bed. The tanker pressed up against the rear of the truck—it was going to ram it into the fast-approaching building.

Terminator grabbed an M-16 and climbed over the pickup and up to the truck cab window. He emptied the

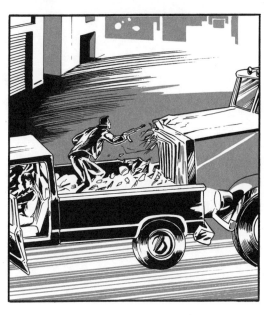

*The tanker was going to ram them
into the fast-approaching building.*

weapon into his rival at point-blank range. Then he wrenched the steering wheel to the left, causing the tanker to turn and tip on its side. The vehicle slid out of control, and Terminator climbed on top of the cab.

Just ahead, John drove straight into the wide mill entrance, but he couldn't stop in time and crashed.

The tanker hit the opening and bent

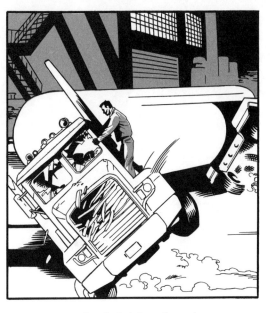

The vehicle slid out of control.

with a long agonizing scream, flinging Terminator inside, where he rolled to safety.

Freezing liquid nitrogen poured out and sprayed everywhere. The foreman hit the alarm, and all the steelworkers fled from deep inside the noisy mill, abandoning their posts.

John and Sarah watched from the wrecked pickup. The T-1000 emerged

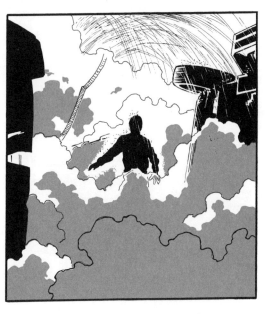

*Freezing liquid nitrogen poured
out and sprayed everywhere.*

in a shower of ultracold liquid that covered it completely. With each step, the machine could feel itself solidify. As it labored forward, one foot froze to the ground. The T-1000 tugged at it, frustrated, until the leg broke off at the ankle.

Then the other leg broke, and the T-1000 stumbled forward, catching itself with one hand. As it straightened,

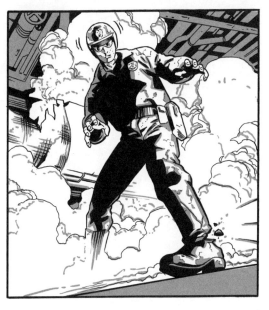

As the machine labored forward, one foot froze to the ground.

its arm broke off as well. For the first time, the metal being understood fear as the freezing chemical crystallized its entire structure.

Terminator drew his .45, experiencing a very different emotion.

"*Hasta la vista,* baby." He fired, one bullet shattering the machine into a million fragile pieces.

 Their victory would be short-

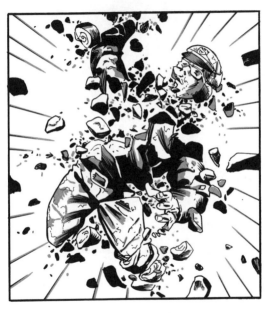

"Hasta la vista, *baby.*"

lived. Molten steel had begun to pour forth from the abandoned furnaces, radiating waves of intense heat.

The frozen metal fragments began to liquify into shimmering mercury puddles, which gathered together in an ever-larger pool. The metal rose and took shape.

"We don't have much time,"

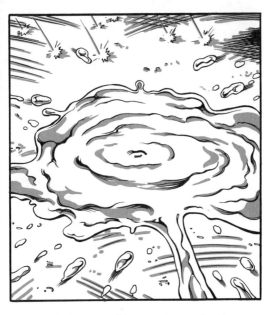

The frozen metal fragments began to liquify.

Terminator said. He grabbed the final M-79 grenade.

Sarah, John, and the cyborg made their way deeper into the steel mill, but Terminator knew it was useless to run. Over John's protests, he stayed behind to try and defeat his rival alone.

Out of the thick steam, the T-1000 appeared suddenly and knocked Terminator's M-79 away. The two

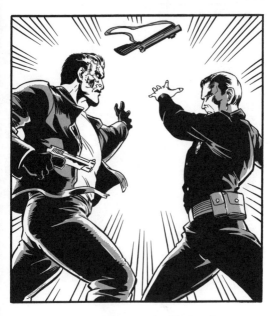

*The T-1000 appeared suddenly and
knocked Terminator's M-79 away.*

wrestled, each matching the other in brute force.

But Terminator got his arm caught in a giant gear mechanism and found himself stuck. Rather than destroy him, the T-1000 left Terminator to contemplate his inferior technology.

Sarah lowered John onto a conveyor belt, which carried him away as the T-1000 approached. She frantically

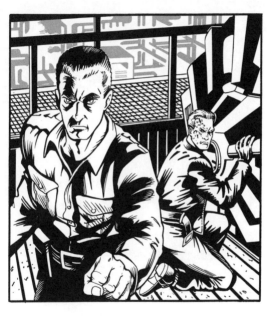

The T-1000 left Terminator to
contemplate his inferior technology.

loaded a shell into her high-powered riot gun and blasted a hole in the T-1000's head.

But after a brief moment, the hole closed, and the T-1000 pinned Sarah through the shoulder with a finger-spike before she could reload and fire.

"Call to John," it ordered, knowing the boy would return to save his mother. "Call to John now."

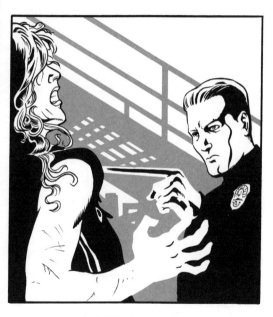

"Call to John now."

Facing certain death, Sarah refused.

Then the T-1000 was split from shoulder to waist by a six-foot-long steel bar. It staggered back, struggling to reform itself.

Terminator had severed his own arm to get free, arriving just in time to save Sarah.

In a fury, the T-1000 drove the terminator back, sending him tum-

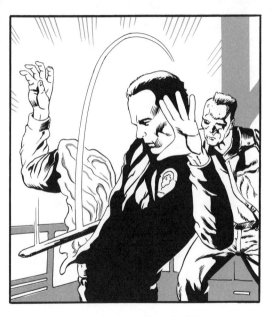

Then the T-1000 was split from shoulder to waist.

bling down a flight of steps. He landed in front of a two-ton I-beam on a rolling track.

The T-1000 slammed the girder into the stunned terminator. It did so again, and again, and again, crushing the terminator's internal armor and skull.

Terminator fell, his servos ratcheting and slipping. He grabbed the floor grating and pulled himself along, still

*The T-1000 slammed the girder
into the stunned terminator.*

trying to fight. Just ahead, he could see the abandoned M-79.

The T-1000 raised the steel bar and with a final thrust speared the terminator and ruptured his main power cells. The terminator short-circuited and stopped moving.

Elsewhere in the mill, John heard his mother calling. He ran to

The terminator short-circuited and stopped moving.

the voice, up to a platform above an enormous smelter crucible.

"John, help me," Sarah said, barely able to walk. "Help me."

John took a step and froze. Another Sarah, holding a rifle, walked up behind him.

"John, get out of the way!" she yelled.

"John, get out of the way!"

He did, and the decision saved his life.

Sarah had fully reloaded the riot gun, and now she pumped shell after shell into the T-1000. She drove it to the edge of the platform . . .

And ran out of ammunition.

The T-1000 healed its wounds, straightened, and wagged its finger

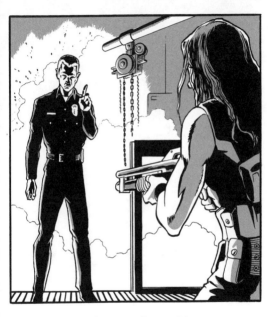

Sarah ran out of ammunition.

disapprovingly. Nothing could stop it now.

At that moment, Terminator appeared, pulled up on a rotating gear, and fired the last M-79 grenade into the T-1000's belly. The terminator had rerouted his power supply and reawakened.

The grenade's explosion shattered the liquid machine. With a sickening

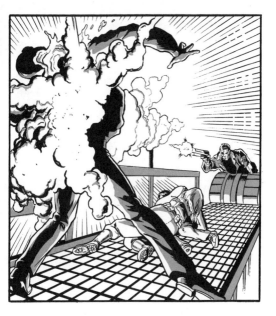

Terminator fired the last M-79
grenade into the T-1000's belly.

metallic screech, it fell off the platform and into the vat of molten steel below.

The T-1000 flailed in the super-heated bath, morphing frantically into every shape it knew, but it was melting and couldn't hold the forms.

In minutes, the silver body lost its integrity and spread like a slick, becoming completely absorbed in the molten steel.

The silver body lost its integrity and spread like a slick.

 "Is it dead?" John asked.

"Terminated," the cyborg replied.

John took the first terminator's metal forearm from his backpack and threw it into the vat. Then he tossed in the computer chip.

"It's over," Sarah sighed.

"No. There is one more chip." Terminator pointed to his skull. Then he handed Sarah the lift control. "I

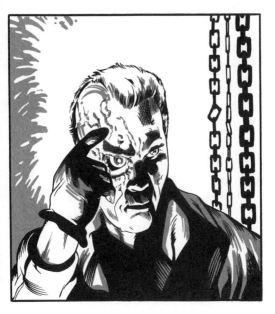

"No. There is one more chip."

cannot self-terminate. You must lower me into the steel."

John became frantic. "No!" he yelled. "It'll be okay. Stay with us! Don't do it!"

"It must end here."

"I *order* you not to go!" John commanded.

Terminator touched the boy's tear-stained cheek.

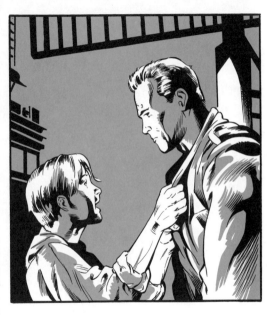

*"I order *you* not to go!"*

"I know now why you cry. But it is something I can never do."

John hugged the machine. Then the terminator stepped onto a hook at the end of a chain over the crucible, and Sarah lowered him down until he was completely submerged.

Safe at last, mother and child held each other.

As they did, Sarah felt a glimmer of

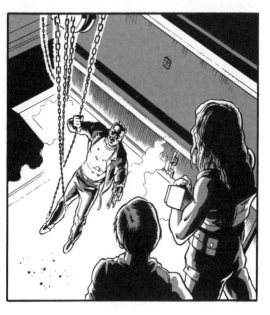

Sarah lowered him down until he was completely submerged.

hope. The future was once again unknown, and, she thought, if a terminator could learn the value of human life, maybe people could, too.

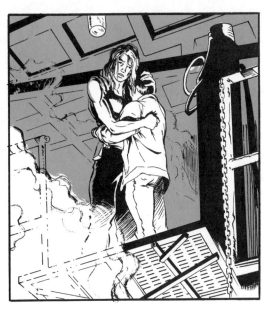

Safe at last, mother and child held each other.

MIGHTY
CHRONICLES

Packed with non-stop action,
MIGHTY CHRONICLES™
are the little books with the big punch.
Look for other titles in
this exciting series, including
Star Wars®, The Empire Strikes Back™, Return of the Jedi™,
Hercules: The Legendary Journeys™,
The Lost World™, The Mask of Zorro™,
Raiders of the Lost Ark™,
Xena: Warrior Princess™

Collect them all!